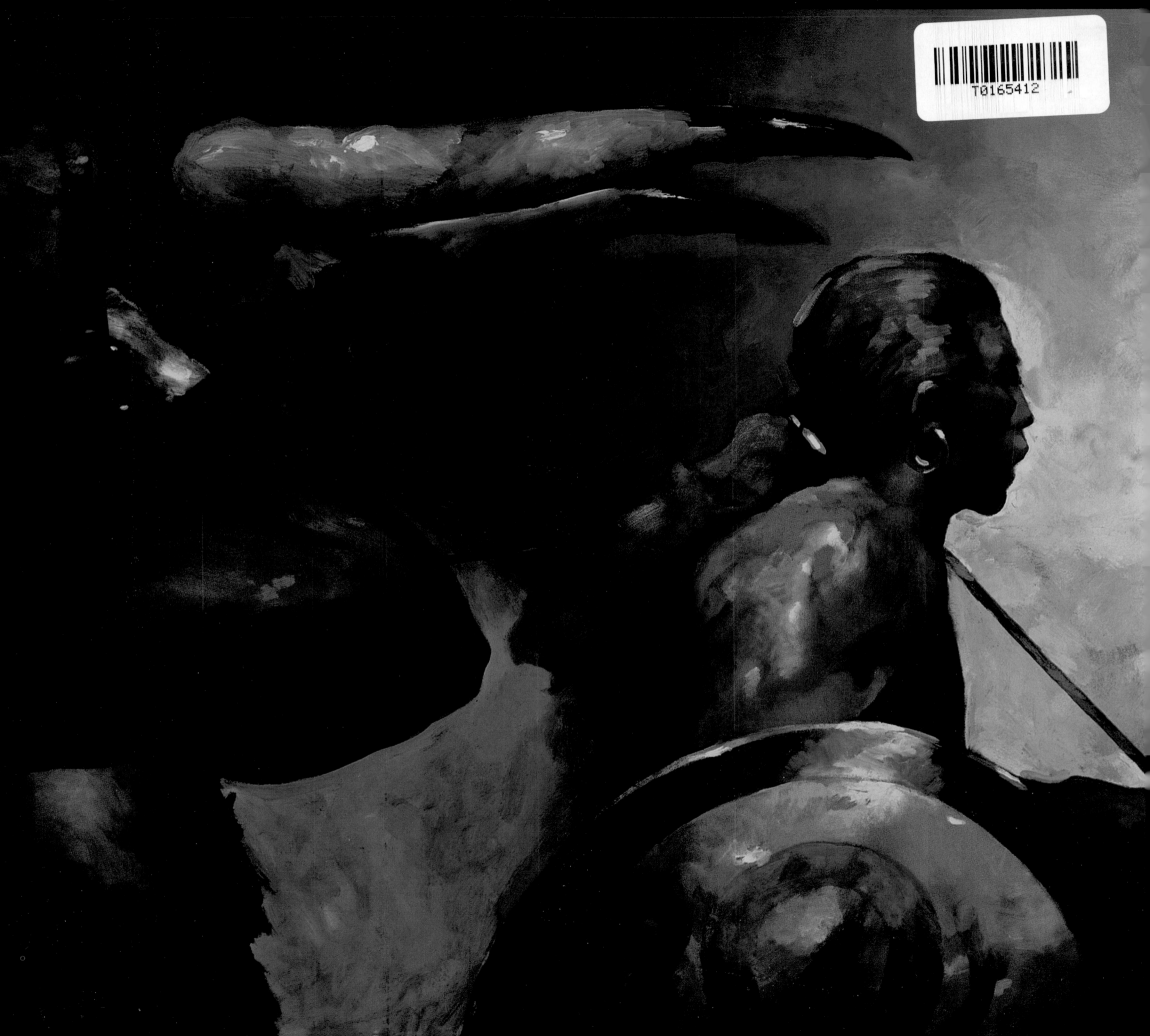

2 0 0 7 C A L E N D A R ~ P O R T F O L I O

Jeffrey Jones

When it comes to painting beautiful women and sword-wielding warriors, Jeffrey Jones was the first—before Boris, Steranko, the Hildebrandts, or Bisley—to compete as a heroic fantasy painter with the great, Frank Frazetta! Jones' inspired work has graced the covers of hundreds of science fiction and heroic fantasy books, he was poster artist for the *Dragonslayer* movie and he has illustrated stories by both, Conan creator Robert E. Howard and Tarzan creator Edgar Rice Burroughs.

Jones sequential art excursions included: *Creepy, Eerie, Wonder Woman,* and *Flash Gordon.* The popular 1970s Renaissance in comics and fantasy art was led by Jones and his Studio mates; Michael Kaluta, Bernie Wrightson, and Barry Windsor-Smith. He then created two of his best remembered works: *Idyl* for *National Lampoon* followed by *I'm Age* for *Heavy Metal* magazine. The often talked about, sometimes controversial Jeffrey Jones, is an evolving artist who has bridged the gaps between comics, science fiction, heroic fantasy and Fine Art as no other man or woman ever has.

Vanguard's *JEFFREY JONES SKETCHBOOK* is exquisitely designed by award-winning artist George Pratt. The 120-page book includes painted covers; commentary by the artist, George Pratt, J. David Spurlock; and an introduction by Michael Friedlander.

December 2006

Sunday	Monday	Tuesday	Wednesday	Thursday	Friday	Saturday
						1
2	3	4	5	6	7	8
9	10	11	12	13	14	15
16	17	18	19	20	21	22
23	24	25	26	27	28	29
30	31					

January 2008

Sunday	Monday	Tuesday	Wednesday	Thursday	Friday	Saturday
		1	2	3	4	5
6	7	8	9	10	11	12
13	14	15	16	17	18	19
20	21	22	23	24	25	26
27	28	29	30	31		

Editorial contributions and collective contents © 2007 Vanguard Productions. Office of publication 390 Campus Drive Somerset, NJ 08873.
Art Direction by J. David Spurlock. Design by Dean Motter. Production assistance by Renae Essinger, Andrew Gaska Dan Zimmer, Murphy Anderson III.
www.creativemix.com/vanguard Special thanks to Comic Buyers Guide magazine (www.CBGXtra.com)
Printed in China

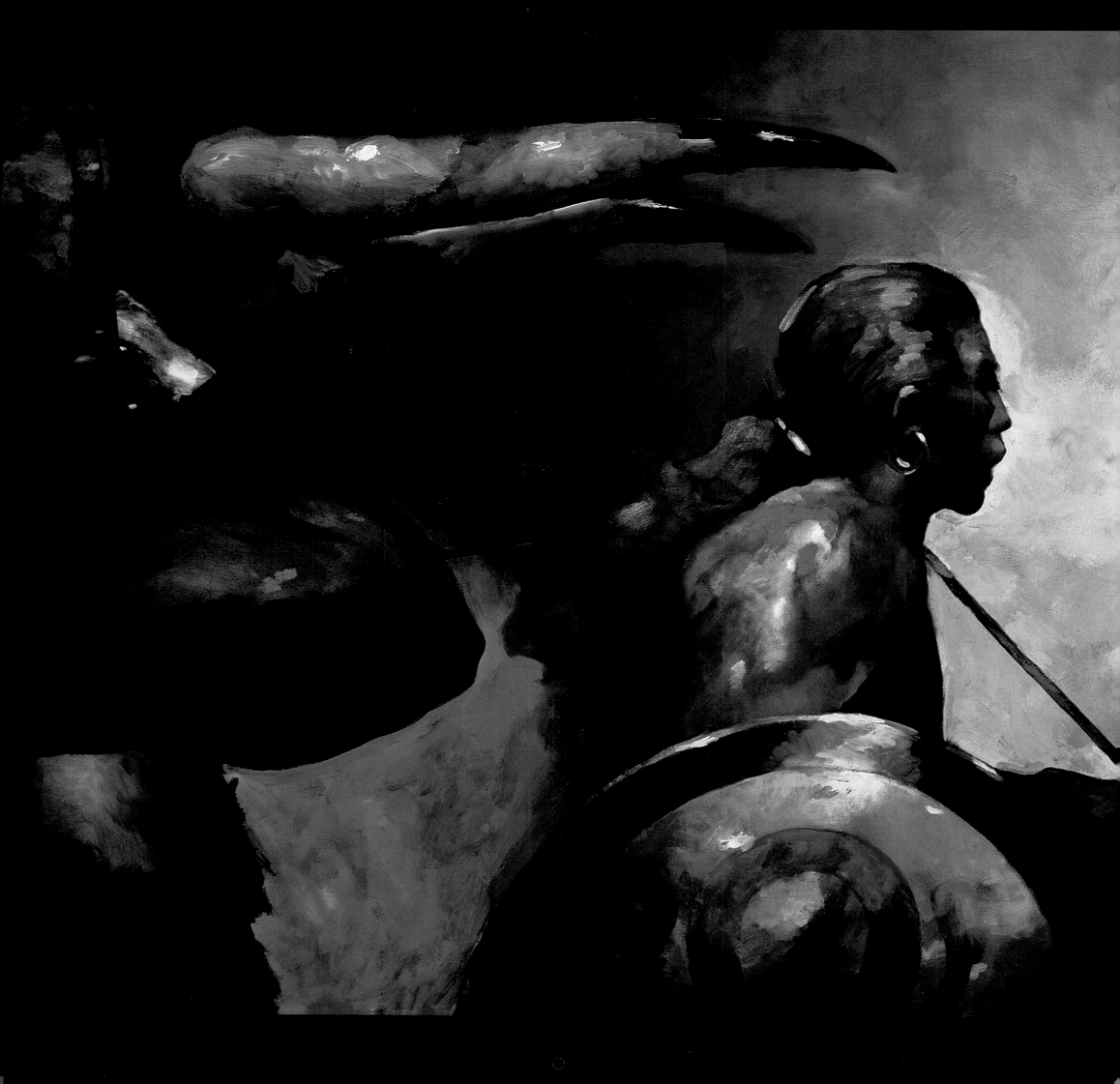

Wally Wood

When legendary cartoonist Wally Wood became *Mad* magazine's first star artist he had already revolutionized comic books with his *Weird Science* sci-fi work which put him on *Entertainment Weekly*'s all-time top-100 list. Wood co-created *Mars Attacks* for bubble gum cards and the movie, designed the super-collectible *Fireball XL-5* lunchbox, and the red costume as used in the comics and major motion picture, *Daredevil*. He also produced art for an unfinished film collaboration based on his *Wizard King—King of the World* graphic novel, with *Fritz the Cat, Wizards, Lord of the Rings,* and *Cool World* film maker Ralph Bakshi!

MAD and *Tales from the Crypt* publisher Bill Gaines called Wood "the greatest science fiction artist that ever lived." *Entertainment Weekly*'s Sci-Fi Top 100: Cover Story (10/16/98) ranked Wood's *Weird Science* comics #35, besting top films *Brazil, Soylent Green, Mad Max, Slaughterhouse Five* & *Forbidden Planet*.

THE KING OF THE WORLD, volume I of Wallace Wood's THE WIZARD KING trilogy, is similar in tone and setting to J.R.R. Tolkien's *The Lord of the Rings* trilogy. In this book, MAD magazine and *Daredevil* comics artist extraordinaire, Wally Wood, takes us on a magical journey filled with elves, warriors, wizards, maidens, Unmen and kings!

JANUARY

SUNDAY	MONDAY	TUESDAY	WEDNESDAY	THURSDAY	FRIDAY	SATURDAY
	1 NEW YEAR'S DAY	2	3	4	5	6
7	8	9	10 Jeffrey Jones (1944)	11	12	13
14	15 MARTIN LUTHER KING DAY	16 David M. DeVries (1966)	17	18	19 Tom Yeates (1955)	20
21	22	23 Klaus Janson (1952)	24 John Romita (1930)	25	26 Jules Feiffer (1929)	27 Frank Miller (1957)
28	29	30	31			

FEBRUARY

				1	2	3
4	5	6	7	8	9	10
11	12	13	14	15	16	17
18	19	20	21	22	23	24
25	26	27	28			

Frank Brunner

The work of Frank Brunner reflects a unique sensibility, combining heroic design, and a lush eroticism with a touch of whimsy. After building his reputation, in the 1970s, as a seminal illustrator of the classic *Dr. Strange*, *Warp*, *Elric* and *Howard the Duck*, Frank Brunner left comics and single-image illustration in favor of decades of work at many top California animation studios. Brunner has recently returned to both the East Coast and his original market as a fantasy illustrator. The artist is now showcased in a fantasy-art retrospective from Vanguard. In the book, *EYES of LIGHT: The Fantasy Drawings of Frank Brunner*, the artist displays a luxurious spread of subjects and characters: Conan, Dr. Strange, Faeries, Elric, Alice in Wonderland, Bran Mac Morn, Howard the Duck, Black Widow, Dragons, Red Sonja, Superman, Clea, Jonny Quest, Pirates of Dark Water, Wizards, nudes and more all in this long-over-due fantasy-art tour de force.

EYES of LIGHT: The Fantasy Drawings of Frank Brunner is available in both hard cover and softcover editions. Also available from Vanguard is Frank's masterful heroic-fantasy Duck painting, *Raiders of the Lost Egg*.

FEBRUARY

SUNDAY	MONDAY	TUESDAY	WEDNESDAY	THURSDAY	FRIDAY	SATURDAY
		JANUARY 1 2 3 4 5 6 7 8 9 10 11 12 13 14 15 16 17 18 19 20 21 22 23 24 25 26 27 28 29 30 31		1	2	3 GROUNDHOG DAY
4	5	6	7 Bob Camp (1956)	8	9 Frank Frazetta (1928)	10
11	12	13	14 VALENTINE'S DAY	15 Art Spiegleman (1948) Matt Groening (1954)	16	17 Curt Swan (1920)
18 CHINESE NEW YEAR YEAR OF THE PIG Gahan Wilson (1930)	19 PRESIDENTS' DAY	20	21 Frank Brunner (1949)	22	23	24
25 George Harrison (1943)	26	27	28	**MARCH** 1 2 3 4 5 6 7 8 9 10 11 12 13 14 15 16 17 18 19 20 21 22 23 24 25 26 27 28 29 30 31		

Above: Art © 2007 Frank Brunner. From the Vanguard book, *The Fantasy Drawings of Frank Brunner.*

Roy G. Krenkel

Influenced by early masters J. Allen St. John, J. C. Coll and Franklin Booth, Roy G. Krenkel has inspired generations of fantasy artists with his portrayals of futuristic cities, prehistoric beasts, Mongol hordes, jungle men and bodacious beauties. From pulp-styled drawings of the late-40s to early work in EC Comics' *Weird Science*, and defining art on *Tarzan*, *Conan*, and *Wizard of Oz*, Vanguard's *RGK: THE ART OF ROY G. KRENKEL* is of interest to anyone whose imagination has been inspired by the stories of Edgar Rice Burroughs or Robert E. Howard!

The Eisner Award nominated book, *RGK: THE ART OF ROY G. KRENKEL* is the first major collection of the fantasy artist's work in 20 years, profusely illustrated with over 250 illustrations that provide a rich overview of the artist's life. Comprehensive text includes commentary by J. David Spurlock, *Star Wars* illustrator Al Williamson, master painter, Frank Frazetta, and more. Krenkel's fully-painted illustrations are well represented along with a plethora of never-before-published drawings. The book is especially of interest to Tarzan, Conan, fantasy, sci-fi and comics art fans. Krenkel and associate Frank Frazetta were the top Edgar Rice Burroughs book cover illustrators of the 1960s. *RGK* is full of iconic characters and enjoys the support of Edgar Rice Burroughs, Inc.

MARCH

SUNDAY	MONDAY	TUESDAY	WEDNESDAY	THURSDAY	FRIDAY	SATURDAY
FEBRUARY 1 2 3 4 5 6 7 8 9 10 11 12 13 14 15 16 17 18 19 20 21 22 23 24 25 26 27 28	**APRIL** 1 2 3 4 5 6 7 8 9 10 11 12 13 14 15 16 17 18 19 20 21 22 23 24 25 26 27 28 29 30			**1** William M. Gaines (1922) Arnold Drake (1924)	**2**	**3** Max Allan Collins (1948)
4	**5**	**6** Will Eisner (1917)	**7**	**8**	**9**	**10**
11	**12** Jack Kerouac (1922)	**13**	**14**	**15** Dan Adkins (1937)	**16**	**17** ST. PATRICK'S DAY Flo Steinberg
18	**19**	**20**	**21** Al Williamson (1934)	**22** Bernard Krigstein (1919)	**23**	**24**
25	**26** Mitch O'Connell (1961)	**27**	**28**	**29** Mort Drucker (1929) Val Mayerick (1950) Marc Silvestri (1959)	**30**	**31**

Above: Art © 2007 The estate of Roy Krenkel. From the Vanguard book, *RGK: The Art of Roy G.Krenkel.*

●

John Buscema

John Buscema began his career at Marvel (Timely) Comics in 1948, working with many notables, including Syd Shores (Captain America), and Carl Burgos (The Human Torch). He left the staff position to freelance for a variety of publishers. During the great comic-book implosion of the late-1950s, he turned to advertising illustration, working for two Manhattan studios, one of which, included superstar illustrator, Bob Peak. In 1966, Stan Lee enticed Buscema to return to Marvel by offering to match his advertising income. There, he was inspired by Jack Kirby's dynamic work and went on to become one of the company's most prolific and popular artists. His approach came to epitomize the Marvel style. He has drawn every major Marvel character—including landmark runs on *Silver Surfer*, the *Avengers*, *Thor*, *Wolverine*, *Sub-Mariner*, *Fantastic Four*, and *Spider-Man*—but prefers non-superhero characters, such as Tarzan and Conan the Barbarian. He illustrated the latter for more than a quarter of a century in comic books, magazines, and newspaper strips.

THE JOHN BUSCEMA SKETCH-BOOK presents a collection of the artist's personal drawings and studies. Done for his own enjoyment, practice, or self-expression, the art offers a unique appreciation of his draftsmanship and creativity on a variety of subjects.

Accompanying text by Spurlock and Buscema addresses both the artist's career and his technique. The book also includes a major essay by Steranko covering Buscema's entire career.

VANGUARD

Sketchbook
Compiled and Edited by J. David Spurlock
Introduction by Jim Steranko

John Buscema

APRIL

SUNDAY	MONDAY	TUESDAY	WEDNESDAY	THURSDAY	FRIDAY	SATURDAY
1 APRIL FOOL'S Sheldon Mayer (1917)	2	3 PASSOVER BEGINS	4 Joe Orlando (1927)	5 Gil Kane (1926) Arthur Adams (1963)	6 GOOD FRIDAY	7
8 EASTER	9	10	11	12	13	14 Sheldon "Shelly" Moldoff (1920) Dave Gibbons (1949) Chuck Dixon (1954) Gerhard (1959)
15 Tom Sutton (1937)	16	17	18	19	20	21
22	23	24	25	26 George Tuska (1916) Kerry Gammill (1954)	27	28 Dick Ayers (1924) Will Murray (1953)
29	30					

MARCH

				1	2	3
4	5	6	7	8	9	10
11	12	13	14	15	16	17
18	19	20	21	22	23	24
25	26	27	28	29	30	31

MAY

	1	2	3	4	5	
6	7	8	9	10	11	12
13	14	15	16	17	18	19
20	21	22	23	24	25	26
27	28	29	30	31		

Alex Schomburg

Alex Schomburg has won every major award for both science fiction and comic book art, from the Hugo Lifetime Achievement Award to the Inkpot, the Doc Smith Lensman Award, and the Frank R. Paul Award. He was inducted posthumously into the Eisner Awards Hall of Fame.

During World War II, Schomburg turned out a plethora of ornate, flamboyant, and outrageously pro-American comic book covers jammed with detail. Schomburg was Timely-Marvel's definitive 1940s cover artist. After the war, Schomburg's comics subjects shifted toward adorable pin-up quality jungle girls and sci-fi (often signed "*Xela*") in the trademark airbrush style that made the artist famous as a book and magazine illustrator. These fabulous works have inspired many pop-culture historians to consider Schomburg the all-time greatest Golden Age of Comics cover artist.

THE THRILLING COMIC BOOK COVER ART OF ALEX SCHOMBURG compiled By Mr. X and *Terminal City* creator, Dean Motter and *HAL FOSTER: PRINCE OF ILLUSTRATORS* editor, J. David Spurlock collects, for the first time, a host of tantalizing Schomburg treasures in one volume.

Superheroes, jungle girls, robots, wild animals, and space travelers abound in these romantic and nostalgic Pop-Art icons of a bygone era.

MAY

SUNDAY	MONDAY	TUESDAY	WEDNESDAY	THURSDAY	FRIDAY	SATURDAY
APRIL 1 2 3 4 5 6 7 8 9 10 11 12 13 14 15 16 17 18 19 20 21 22 23 24 25 26 27 28 29 30		**1** Alex Niño (1940) Tim Sale (1956)	**2** Doug Wildey (1922)	**3** Denny O'Neil (1939) Bill Sienkiewicz (1958) Adam Hughes (1967) John Cullen Murphy (1919)	**4**	**5** BUDDHA'S BIRTHDAY CINCO DE MAYO Stan Goldberg (1932) Moebius [Jean Giraud] (1938)
6	**7** Michael T. Gilbert (1951)	**8**	**9**	**10** Alex Schomburg (1935)	**11**	**12** Steve Winwood (1948)
13 MOTHERS DAY	**14** Jack Bruce (1943) Bob Wayne (1954)	**15**	**16**	**17**	**18** Don Martin (1939) Arthur Suydam (1953)	**19**
20	**21**	**22** Carlos Garzón (1945)	**23** Win Mortimer (1919) John Bolton (1951)	**24**	**25** Barry Windsor-Smith (1949)	**26**
27 Harlan Ellison (1904)	**28** MEMORIAL DAY	**29**	**30** Mort Meskin (1916) Mike W. Barr (1952) Kevin Eastman (1962)	**31**	**JUNE** 1 2 3 4 5 6 7 8 9 10 11 12 13 14 15 16 17 18 19 20 21 22 23 24 25 26 27 28 29 30	

Above: Art from the Vanguard book, *The Thrilling Comic Book Cover Art of Alex Schomburg.*

J. Allen St. John

Amazing Stories, *Blue Book*, *Argosy*, and *Weird Tales* were the top pulp magazine titles of the 1920s and 1930s, and J. Allen St. John's imaginative, visual flights-of-fantasy illustrations are the era's most memorable. St. John (the favorite artist of the great author and creator of Tarzan, Edgar Rice Burroughs) illustrated *Tarzan and the Golden Lion*, *Tarzan the Terrible*, *The Beasts of Tarzan*, as well as Burroughs' sci-fi creations, *At The Earth's Core*, *Pirates of Venus*, and the many adventures of John Carter on Mars.

St. John became a professor of drawing and painting at The American Academy of Art and the Chicago Art Institute, but his greatest notoriety came as he ventured into the colorful world of pulp magazine and book illustration. Readers of fantasy and science fiction preferred St. John to contemporaries Schoonover, Montgomery Flagg, and N. C. Wyeth, and the artist led the way for future masters, Foster, Krenkel, Hildebrandt, and Frazetta.

Vanguard's *GRAND MASTER OF ADVENTURE: THE DRAWINGS OF J. ALLEN ST. JOHN*, by J. David Spurlock, collects, for the first time, the exquisite pen, ink and pencil illustrations of the grand Tarzan artist. The soon to be released companion book, *GRAND MASTER OF FANTASY: THE PAINTINGS OF J. ALLEN ST. JOHN*, by Stephen Korshak and J. David Spurlock showcases the master's canvases including his painting for Golden Blood, which is seen here.

JUNE

SUNDAY	MONDAY	TUESDAY	WEDNESDAY	THURSDAY	FRIDAY	SATURDAY
					1	**2**
3 Tom Gill (1913)	**4**	**5** Wayne Boring (1905)	**6** Arlen Schumer (1958)	**7** Graham Ingels (1915) Larry Hama (1949) Mark Schultz (1955)	**8** C.C. Beck (1910)	**9**
10 Charles Vess (1951) Scott McCloud (1960)	**11**	**12** Len Wein	**13**	**14**	**15** Ross Andru (1925) Neal Adams (1941) Don McGregor (1945)	**16** Frank Thorne (1930)
17 FATHERS DAY Hillary Barta (1957)	**18**	**19** Julie Schwartz (1915)	**20**	**21** Al Hirschfeld (1903)	**22**	**23**
24	**25** Alex Toth (1928)	**26** Tom DeFalco (1950)	**27** Pat Boyette (1923)	**28**	**29** Mike Richardson (1950) Bo Hampton (1954)	**30**

MAY

	1	2	3	4	5	
6	7	8	9	10	11	12
13	14	15	16	17	18	19
20	21	22	23	24	25	26
27	28	29	30	31		

JULY

1	2	3	4	5	6	7
8	9	10	11	12	13	14
15	16	17	18	19	20	21
22	23	24	25	26	27	28
29	30	31				

Golden Blood by J. Allen St.John, from *Grand Master of Fantasy: The Paintings of J. Allen St. John.*

Arthur Suydam

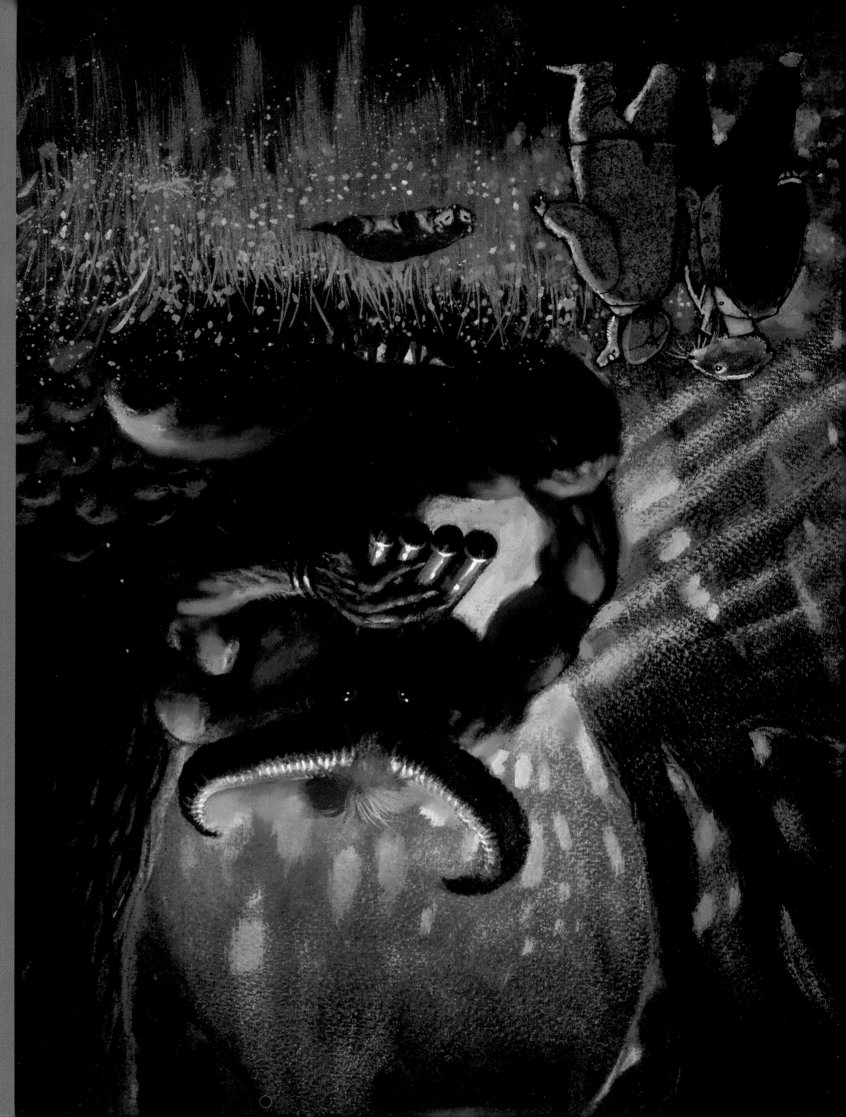

Arthur Suydam is a Renaissance man who is equally adept as a prose writer, fantasy painter, children's book illustrator, folk musician and visual storyteller. New York's Alexander Gallery, upon exhibiting his work, called Suydam's watercolors "some of the finest ever created." As Aristotle said, "No great genius is without an admixture of madness." The Society of Illustrators member and Spectrum Award winner hides himself away in the confines of his studio, married to his art, shunning the "popular" projects, preferring to grow and create on the fringe (though Suydam can't help the occasional mega-hit like his recent best-selling series of *Marvel Zombies* cover paintings).

THE FANTASTIC ART OF ARTHUR SUYDAM explores the many sides of the artist's work, contrasting lushly vegetated fantasy worlds with scorched, distant science-fiction scenes. Influenced by Maxfield Parrish, Frank Frazetta, Arthur Rackham and Heinrich Kley, Suydam reveals new, rare and classic images featuring *The Wind in the Willows*, *Tarzan*, *Fireflies*, *Bret Rabbit*, *Predator*, *Giants*, *Aliens*, *Batman*, recent Image Comics projects and his definitive *Heavy Metal* character, the Mudwog.

JULY

SUNDAY	MONDAY	TUESDAY	WEDNESDAY	THURSDAY	FRIDAY	SATURDAY
1	2	3	4 INDEPENDENCE DAY	5 Shel Dorf (1933)	6	7
8	9 Virginia Romita	10 Joe Shuster (1914)	11	12	13 Tom Palmer (1942)	14 BASTILLE DAY
15	16	17	18	19	20 Dick Giordano (1932)	21
22	23	24 Colleen Doran	25	26	27 Bill Pearson (1938)	28 Dick Sprang (1915) Jon J Muth (1960)
29	30	31				

JUNE

					1	2
3	4	5	6	7	8	9
10	11	12	13	14	15	16
17	18	19	20	21	22	23
24	25	26	27	28	29	30

AUGUST

			1	2	3	4
5	6	7	8	9	10	11
12	13	14	15	16	17	18
19	20	21	23	24	25	26
26	27	28	29	30	31	

Paul Gulacy

Star Wars, Batman, James Bond, The Terminator, Master of Kung Fu and Catwoman: Building his reputation on these mega-properties Paul Gulacy has proven one of the most highly regarded comic book illustrators of the last 30 years! The artist populates his innovative and surreal designs with characters that bare resemblance to the likes of Bruce Lee, Marlon Brando and Marlene Dietrich. Gulacy made his initial mark on the art world while at Marvel comics during the Kung Fu craze of the 1970s with *Master of Kung Fu*. Gulacy's work on that title inspired legendary film director Quentin Tarantino to say "*Master of Kung Fu*... hands down my favorite comic book."

Vanguard's *SPIES, VIXENS AND MASTERS OF KUNG FU* examines Gulacy's art in all its glory. The book, compiled by Michael Kronenberg and J. David Spurlock has been acclaimed by Diamond International Galleries' *Scoop* web magazine as one of the top two books on comics art for 2005. Featuring a gallery of his incredibly detailed paintings—some never before published, this is the first book to fully examine Gulacy's body of work. Everything from his comics art to posters, prints, book covers, personal works and paintings are all beautifully reproduced in this eye-catching package. Also included is an Afterword by Steranko.

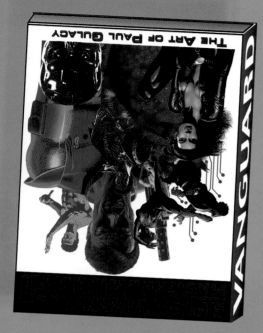

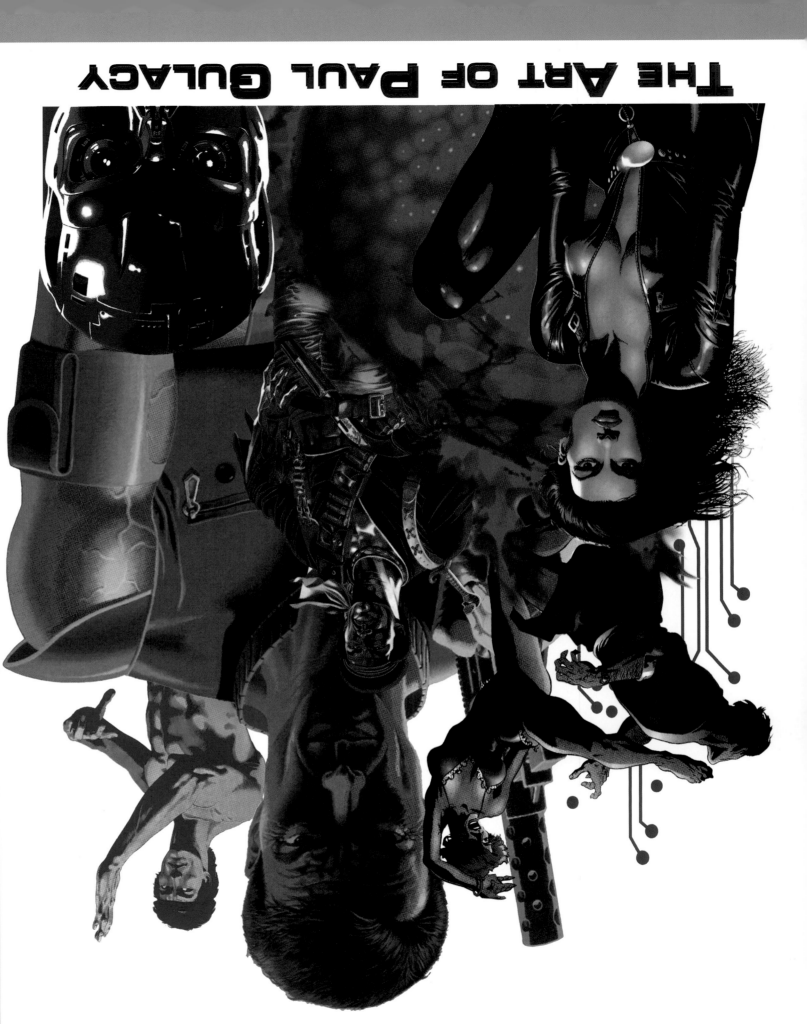

AUGUST

SUNDAY	MONDAY	TUESDAY	WEDNESDAY	THURSDAY	FRIDAY	SATURDAY
	JULY 1 2 3 4 5 6 7 8 9 10 11 12 13 14 15 16 17 18 19 20 21 22 23 24 25 26 27 28 29 30 31		1 Jerry Garcia (1942)	2	3	4
5	6	7	8	9	10	11
12	13	14	15 Paul Gulacy (1953)	16	17 Trina Robbins John Romita jr. (1956)	18 Brian Michael Bendis (1967)
19	20	21	23	24	25	26
26	27 Frank Kelly Freas (1922) Denis Kitchen (1946)	28	29	30 Robert Crumb (1943)	31	

Steve Ditko

The record-breaking box-office hit *Spider-Man* began with the credit, "Based on the comic-book by Stan Lee and Steve Ditko." Ditko is one of the most mysterious men in comic-book history; he refuses to make personal appearances, be photographed, or to be interviewed. He chooses to speak only through his artistic milieu, which, as historian Arlen Schumer noted, "champions the struggle between good and evil, ugliness and beauty, and the weak versus the strong." His groundbreaking depiction of Spider-Man went against type by portraying the character as an everyman loner, underdog, teenager—as a super-antihero.

Ditko's next creation, the occultist Dr. Strange, provided a surrealistic journey through alternate dimensions and realities, which served as precursors to the psychedelia of the late-1960s. After leaving Marvel he created *The Creeper* for DC Comics and his own *Mr. A* and *The Question*, which integrated the Objectivist philosophy of Ayn Rand with his own, and remain as controversial as ever.

Vanguard's *STEVE DITKO: SPACE WARS* features Ditko's eclectic, sometimes surrealistic work which proves both futuristic and retro as he takes us into the cosmos to find star-crossed lovers in the back-stabbing debacle, "Dead Reckoning." Then, the deadliest space ship in the galaxy hovers menacingly over us while the invaders demand complete surrender and our military warns it's useless to resist in "The Conquered Earth." That's just the beginning for the 1st-ever Ditko Sci-Fi collection.

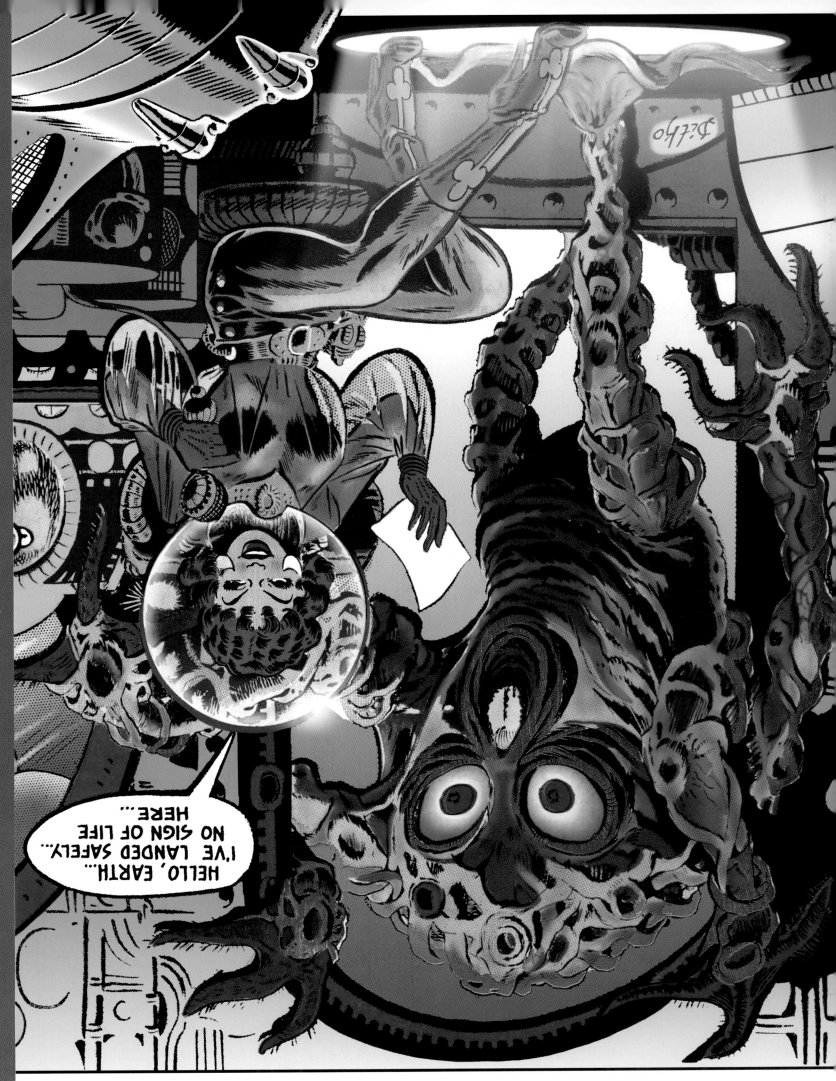

SEPTEMBER

SUNDAY	MONDAY	TUESDAY	WEDNESDAY	THURSDAY	FRIDAY	SATURDAY

AUGUST

			1	2	3	4
5	6	7	8	9	10	11
12	13	14	15	16	17	18
19	20	21	23	24	25	26
26	27	28	29	30	31	

OCTOBER

	1	2	3	4	5	6
7	8	9	10	11	12	13
14	15	16	17	18	19	20
21	22	23	24	25	26	27
28	29	30	31			

SUNDAY	MONDAY	TUESDAY	WEDNESDAY	THURSDAY	FRIDAY	SATURDAY
						1 Gene Colan (1926)
2	**3** LABOR DAY Mort Walker (1923) Paul Chadwick (1957)	**4** Paul Smith (1954)	**5** Bob Chapman (1952)	**6** Sergio Arigonés (1937)	**7**	**8** Archie Goodwin (1937)
9	**10** Gerry Conway (1952)	**11**	**12**	**13** ROSH HASHANAH BEGINS	**14**	**15**
16 Mike Mignola (1960)	**17**	**18**	**19**	**20** Steve Gerber (1947) Steve Ringgenberg (1957)	**21**	**22** YOM KIPPUR BEGINS Will Elder (1922) Peter Kuper (1968)
23 John Coltrane (1926) **30**	**24**	**25**	**26** Louise Simonson (1946)	**27** Jack Katz (1927)	**28** Russ Heath (1926)	**29**

Above art © 2007 Steve Ditko & J. David Spurlock. From the Vanguard book, *Steve Ditko: Space Wars*

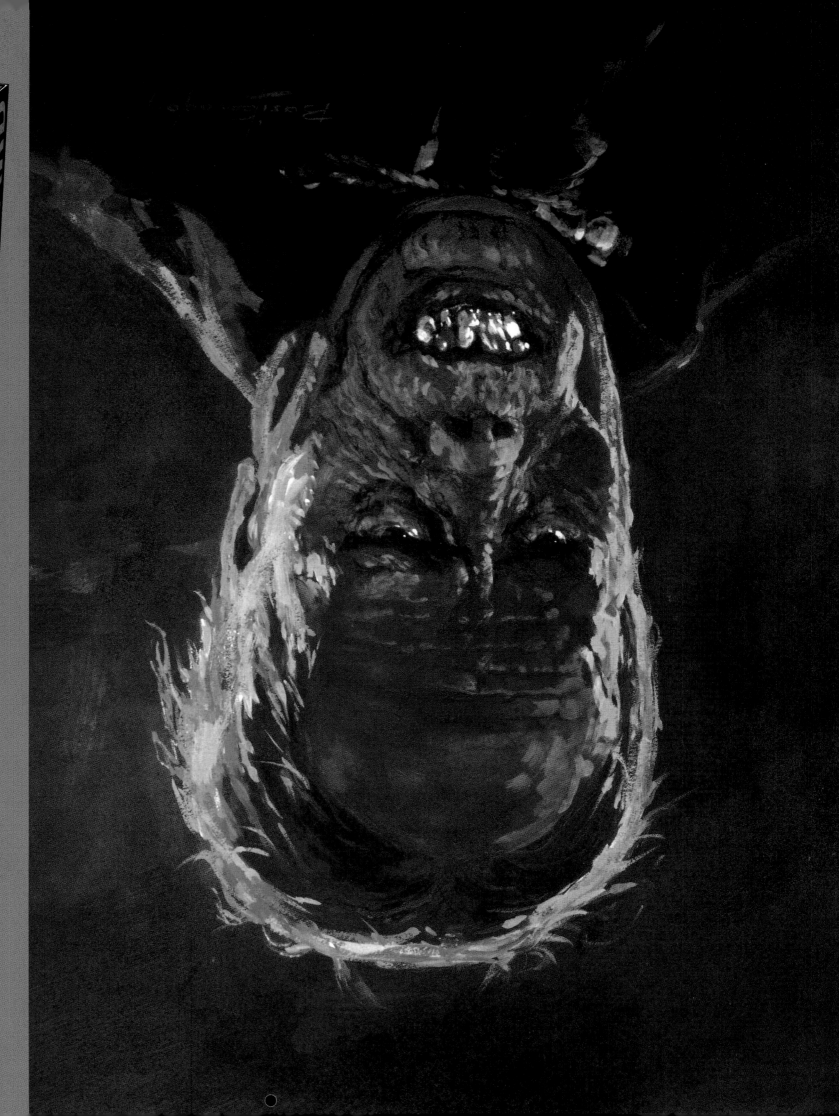

Basil Gogos

The "monster craze" among baby-boomers, sparked by the release of Universal Studios' horror classics to television in the late 1950s, gave birth to a new phenomenon—the monster magazine. *Famous Monsters of Filmland*, filled with monster photos and articles on horror movies and their film stars, was the premier publication for young horror film fans. Issues of the new magazine practically leapt off the newsstand shelves and into kids' hands due in no small way to their striking cover paintings by Basil Gogos. Like a Bizarro world Norman Rockwell, his stylish portraits of horror film characters and stars were seen on magazine covers throughout the '60s and '70s. Gogos' legend as the world's greatest movie monster artist has only grown over the years. His original *Famous Monsters* cover paintings are highly sought-after and are in the collections of many film makers and rock stars on whom he made a lasting impression.

Vanguard's recent hit book, THE *FAMOUS MONSTER MOVIE ART OF BASIL GOGOS* is a celebration of the career of the acknowledged master of film monster portrait art. This long-awaited retrospective features high-quality reproductions of many of the artist's most famous paintings as well as many previously unpublished paintings and drawings of classic film creatures and actors. Gogos' early work in men's adventure magazine and paperback book art is examined, as well as his works in movie posters and other areas. The book, compiled by Kerry Gammill and J. David Spurlock, features an introduction by rock star, movie director and horror collector Rob Zombie.

Introduction by
ROB ZOMBIE
Compiled & Edited by Kerry Gammill & J. David Spurlock

FAMOUS MONSTER MOVIE ART OF
BASIL GOGOS

VANGUARD

OCTOBER

SUNDAY	MONDAY	TUESDAY	WEDNESDAY	THURSDAY	FRIDAY	SATURDAY
	1 J. Allen St. John (1872)	2 Mahatma Gandhi (1869)	3 Harvey Kurtzman (1924)	4	5	6 Alfred Harvey (1913)
7 Howard Chaykin (1950)	8 Harvey Pekar (1939)	9 COLUMBUS DAY John Lennon(1940)	10	11 Joe Simon (1915)	12	13
14	15 Cam Kennedy (1944)	16 Joe Sinnott (1926)	17 Jerry Siegel (1914)	18	19	20 Sid Jacobson
21 Paul Levitz (1956)	22	23	24 Bob Kane (1916) Al Feldstein (1925)	25	26 Larry Lieber (1931)	27 Berni Wrightson (1948)
28 Leonard Starr (1925)	29 Peter Green (1946) Ralph Bakshi (1938) Nick Cuti (1944)	30 Grace Slick (1939) Don Thompson (1935) P. Craig Russell (1951)	31 HALLOWEEN			

NOVEMBER

S	M	T	W	T	F	S
				1	2	3
4	5	6	7	8	9	10
11	12	13	14	15	16	17
18	19	20	21	22	23	24
25	26	27	28	29	30	

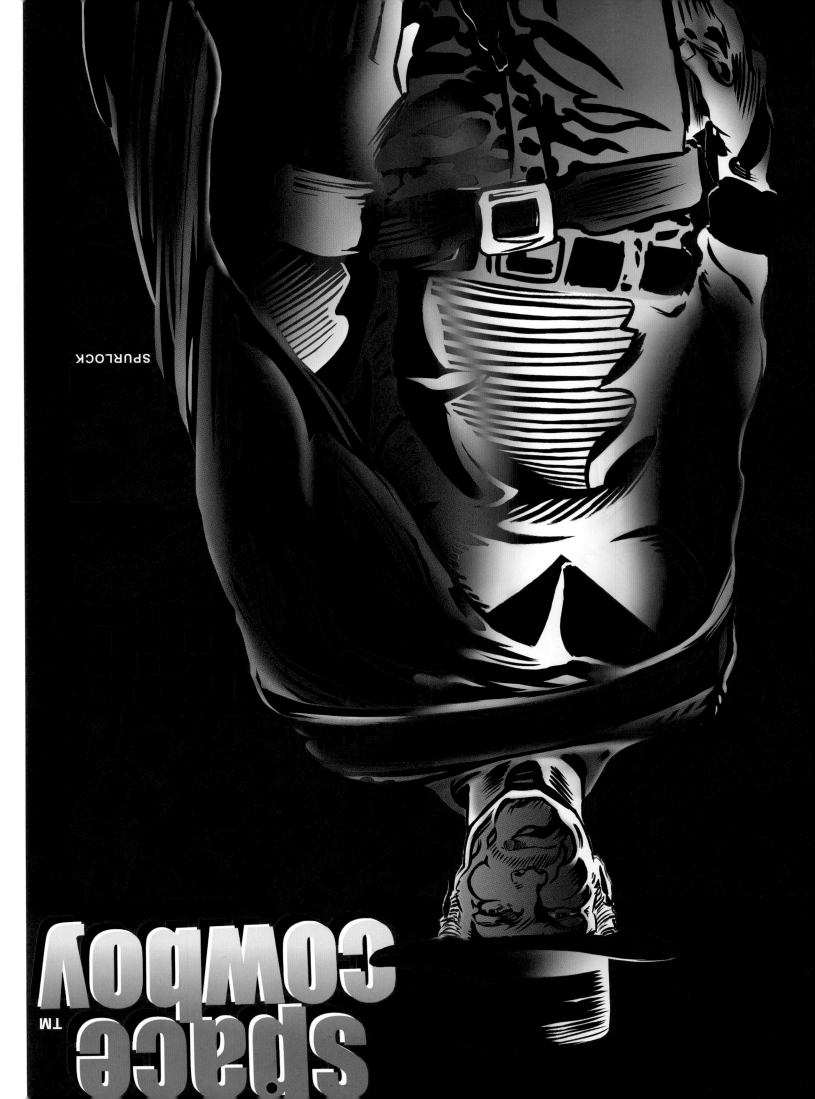

SPURLOCK

space COWBOY ™

J. David Spurlock

"Return with us now to another daring cosmic adventure: Into the future's deepest neb-ulae zooms an adventurer from out of our own past. A shoot-from-the-hip man of courage and integrity in the desolate, cold void of a looming and chaotic cosmos... and they call him, The Space Cowboy!" Those are the words of creator J. David Spurlock. Spurlock is known to art directors around the world as the Prince of Pop Art for his 25 years of commercial illustration work. As an artist, art director or editor, Spurlock has collaborated with *Star Wars* artist Al Williamson, *Indiana Jones* designer Jim Steranko, *Matrix* artist Bill Sienkiewicz, *Batman* artist Neal Adams, *Time magazine* illustrator Barron Storey, *Mars Attacks* co-creator Wally Wood, *Mad magazine* associate publisher Joe Orlando and *Flash* co-creator Carmine Infantino. Spurlock is a behind-the-scenes mover and shaker in the comics world and rep-resents top talents, as well as serving as President of the Dallas Society of Illustrators and Publisher of Vanguard Productions. He has worked for Disney, Sony, Dark Horse Comics, Beckett Publications and MTV, in addition to teaching at NYC's School of Visual Arts. Recent projects include the Eisner Award nominated book RGK: THE ART OF ROY G. KRENKEL, and this man of many hats even squeezes in time to write and draw an annual appearance of his most notable comic-book creation, THE SPACE COWBOY.

November

SUNDAY	MONDAY	TUESDAY	WEDNESDAY	THURSDAY	FRIDAY	SATURDAY
				1	2 Steve Ditko (1927)	3
4	5 GUY FAWKES DAY Jim Steranko (1938)	6	7	8	9	10 Neil Gaiman (1960)
11 VETERAN'S DAY Dave Cockrum (1943)	12	13 Doug Murray (1947)	14	15 Heidi MacDonald	16	17 Alan Moore (1952)
18 J. David Spurlock (1959)	19	20 Chester Gould (1900) Jill Thompson (1966)	21 Vincint DiFate (1945)	22 THANKSGIVING Roy Thomas (1940)	23	24
25	26 Charles M. Schultz (1922)	27 Jimi Hendrix (1942)	28	29 Maggie Thompson (1942)	30	

OCTOBER

	1	2	3	4	5	6
7	8	9	10	11	12	13
14	15	16	17	18	19	20
21	22	23	24	25	26	27
28	29	30	31			

DECEMBER

						1
2	3	4	5	6	7	8
9	10	11	12	13	14	15
16	17	18	19	20	21	22
23	24	25	26	27	28	29
30	31					

Steranko

More than any other comics creator, the name Steranko conjures cutting-edge noir imagery, searing cinematic storytelling, narrative experimentation, and the ethics of perfection to legions of followers who collected his *Captain America*, *X-Men*, *S.H.I.E.L.D.*, *Chandler*, *Heavy Metal*, *Shadow*, and *Superman* work.

Yet, as Steranko's incendiary status grows, so too does the enigmatic persona that shrouds his legend.

He's visualized more classic fictional icons than any other American artist—and now he's added another, The Domino Lady, in a spectacular volume, which incorporates four favorite Steranko themes: pulp fiction, noir mystery, art deco, and beautiful women. A newly-painted cover showcasing equal parts danger, intrigue, and sex appeal sets the tone for the large-sized edition, which was also designed from the first page to last by the artist.

The Domino Lady is the quintessential 1930s pulp vixen, a masked manhunter in a noir deco world, right out of a Warner Bros.-style thriller. Each adventure pits the sultry femme fatale against vicious gangsters and secret societies, all of which are captured by evocative Steranko double-page title illustrations. Steranko has also authored a new thriller that reveals the sintillating secrets of the Domino Lady's lethal origin—for the first time ever! The Vanguard book DOMINO LADY: THE COMPLETE COLLECTION is a total Steranko package!

December

SUNDAY	MONDAY	TUESDAY	WEDNESDAY	THURSDAY	FRIDAY	SATURDAY
				NOVEMBER 1 2 3 4 5 6 7 8 9 10 11 12 13 14 15 16 17 18 19 20 21 22 23 24 25 26 27 28 29 30		1 World Aids Day
2 Jack Davis (1924)	3	4	5 HANUKKAH BEGINS Sam Glanzman (1924)	6 Frank Springer (1929)	7	8 Erik Larsen (1962)
9	10	11 John Buscema (1927)	12 Dan DeCarlo (1919) Fred Kida (1920)	13 Kyle Baker (1965)	14	15
16	17	18	19	20	21 John Severin (1921)	22
23	24 CHRISTMAS EVE	25 CHRISTMAS DAY	26 KWANZAA BEGINS	27	28 Stan Lee (1922)	29 Steve Rude (1956)
30	31 NEW YEARS EVE	**JANUARY** 1 2 3 4 5 6 7 8 9 10 11 12 13 14 15 16 17 18 19 20 21 22 23 24 25 26 27 28 29 30 31				

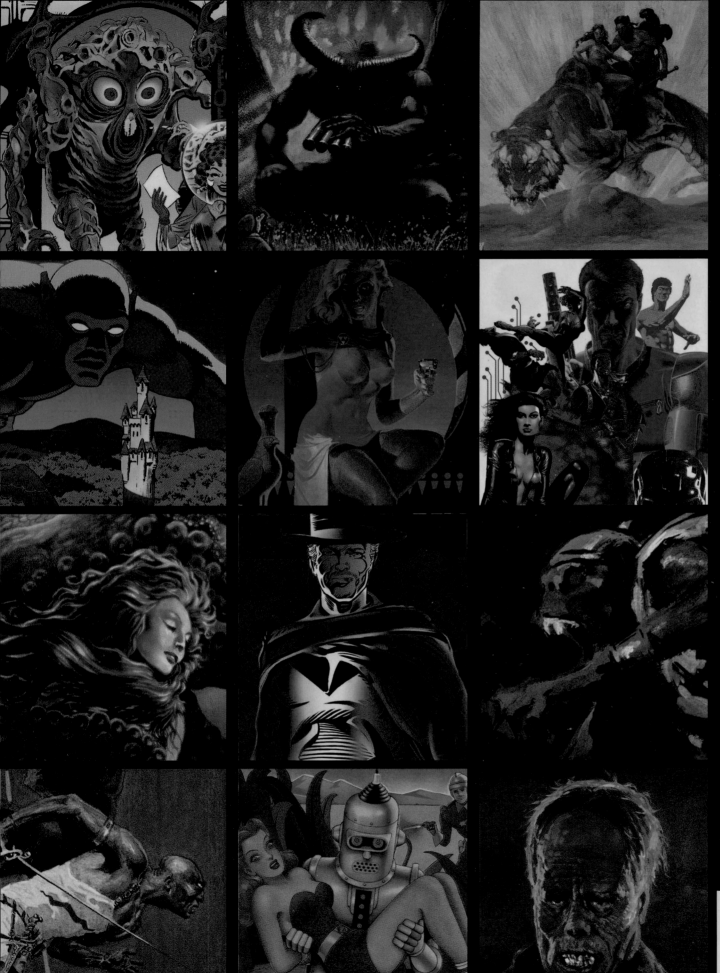

VANGUARD: MASTERS
OF FANTASTIC ART

ISBN 1-887591-99-0
51295>

9 781887 591997